D0532758

BP PORTRAIT AWARD 2002

BP PORTRAIT AWARD 2002

National Portrait Gallery

Published in Great Britain by
National Portrait Gallery Publications,
National Portrait Gallery,
St Martin's Place, London WC2H 0HE

Published to accompany
the BP Portrait Award 2002,
held at the National Portrait Gallery,
London, from 19 June
to 15 September 2002,
and at Aberdeen Art Gallery,
from 28 September to 23 November 2002.

For a complete catalogue
of current publications
please write to the address above,
or visit our website at
www.npg.org.uk/publications

Copyright © National Portrait Gallery, 2002
Introduction © William Packer, 2002
Foreword © Richard E. Grant, 2002

The moral rights of the authors
have been asserted. All rights
reserved. No part of this publication
may be reproduced, stored in
a retrieval system or transmitted
in any form or by any means,
whether electronic or mechanical,
including photocopying, recording
or otherwise, without the prior
permission in writing of the publisher.

ISBN 1 85514 505 7

A catalogue record for this book
is available from the British Library.

Publishing Manager: Celia Joicey
Editor: Susie Foster
Production: Ruth Müller-Wirth
Design: Pentagram
Printed and bound in Italy
by Conti Tipocolor, Florence

The publisher would like to thank
the copyright holders for granting
permission to reproduce works
illustrated in this book. Every effort
has been made to contact the holders
of copyright material, and any
omissions will be corrected
in future editions if the publisher
is notified in writing.

All works copyright © the Artist
unless otherwise stated;
p.14 © Lucian Freud;
pp.19 and 20 © National Portrait
Gallery, London.

Cover photography by Phil Sayer

FOREWORD

Judging the BP Portrait Award can be quite a difficult task. In his final year as Director of the National Portrait Gallery, **Charles Saumarez Smith** discusses both the challenge and the rewards.

When I was appointed Director of the National Portrait Gallery in 1994, I approached the idea of an annual open competition with a certain scepticism and an anxiety that it might be the portrait painters' equivalent of the Royal Academy Summer Exhibition. I had no idea that, as Director, I was ex officio a judge and, more importantly, the person responsible for hanging the exhibition. In the first year that I was involved in the judging, I arrived at an East End warehouse and found myself seated alongside Joanna Drew, the doyenne of the Arts Council, Humphrey Ocean, the artist, and Lord Ashburton, the tall and aristocratic chairman of BP, making judgements about the merits of individual works under the efficient chairmanship of the art historian Norbert Lynton.

I have always found it fascinating that it is relatively straightforward to achieve a consensus over the choice of works. In the short space of time that can be allocated to the inspection of individual pictures, a rapid judgement has to be reached about their qualities and exhibitability – not necessarily the same thing. Over the years, I have also realised that the judging process has certain inbuilt tendencies. For example, when one is viewing six or seven hundred works in a day, there is a tendency to be attracted to the works that distinguish themselves from the run-of-the-mill portraits which observe more traditional conventions. It is also possible to overlook the more subtle, reflective and meditative works.

Every year the process of judging is broadly similar. On the first day we look at all the works submitted and do a preliminary sift, bringing the number down to around two hundred. On the second day we have to reduce the number further to between fifty and sixty-five, in other words to the number of portraits that can be hung satisfactorily in the Gallery. Then we select works

from which we pick the winners and the shortlist. While the overall choice is usually straightforward and the winners often reveal themselves, this year, more than in any previous year, both involved a long process of discussion and voting. The process of judging was made all the more tricky as the judges did not agree. This was partly because we deliberately asked the artists Nicola Hicks and Jock McFadyen to act as judges for a second year running, knowing that they were happy to have arguments about the merits of individual works. But also, for the first time, there were obvious differences of opinion about the importance of narrative in the works chosen and the extent to which the judges should be looking for the exploration of new artistic conventions. Should we select works of photorealism? To what extent should the figure predominate? What, in other words, is the definition of the contemporary portrait? All of these issues were hotly debated.

Like any painting competition, the BP Portrait Award has a particular character to it. It has consistently managed to avoid the stereotype of official portraiture, always preferring the lively, the idiosyncratic and the personal. At the same time, it upholds traditional qualities of composition, depiction and painterliness. As the years have gone by, I have valued more and more the fact that it gives young painters, who are often struggling to make a living, an effective showcase for their work. Through the exposure of a national competition, young artists can often find a public, as well as people who will commission work from them.

After eight years as a judge, I am happy to be handing on to others the tasks of selection. The BP Portrait Award is a wonderful instition, precious in preserving the traditions of figurative art in the public sphere, but at the same time always pushing at the boundaries of the conventions of portraiture.

FOREWORD

Biography, film and photography record both the famous and the infamous for posterity. But actor **Richard E. Grant** believes that it is the painted portrait that has the power to endure.

A film director advised a friend of the artist David Hockney to keep going to the museum: 'The pictures don't talk, they don't move, but they last longer'.

On my first trip to Hollywood, I expected to find numerous statues and sculptures commemorating and celebrating the likes of Charlie Chaplin, Douglas Fairbanks, Mary Pickford, James Dean, Marlon Brando and Marilyn Monroe. Yet when I asked where I might find them, there was a genuine dumbstruck pause, advising that 'the Hollywood waxwork museum is about your best bet'. 'But wax melts,' I countered, 'surely there must be some permanent monument to these famous faces somewhere?' 'Uh uh.'

Perhaps the most prolific portraitist, of the famous and infamous, was Andy Warhol. Warhol made silk screens of photographic images, homogenising them in his unique style, rendering a photo into a 'painted portrait'. His multiple portrait of Monroe is probably as familiar as any of her films, if not more so. Despite making his own films at the Factory, it is his portraits that have endured and continue to arrest our attention. Working from the theory that it takes nine months to form a human, and nine months for the human body to decompose, the painted portrait similarly arrests your attention longer than a photograph, which takes a milli-second to snap. From which I assume it is the element of time that's involved. You can shoot holes through this theory instantly, but the distillation of time inherent in a painting seems to hold our gaze longer.

When asked to write this introduction, I immediately grabbed a dictionary – 'portrait: life-like description, likeness, image, representation, interpretation'. All the things that artists have done and will continue to do, despite the meteoric explosion of photographic, digital and computerised technology, and what's yet to come.

Having been a regular visitor to the National Portrait Gallery in London, I have never tired of seeing the same faces looking back at me. Perhaps because they defy time, like Dorian Gray, by never ageing, even though the period in which they were painted is always obvious. The fascination of seeing a 400-year-old face is at once hypnotic, mysterious and reassuring, making you feel an intimacy with the past that no other medium quite fulfils in the same way. Here is the dress worn by Elizabeth I, mounted in a glass case, lit and labelled. Yet it is powerless to conjure a presence in the way that her portraits manage to do.

Despite the current vogue for art installation and creature 'pickling', the need to represent, interpret and describe each other's faces is indestructible.

FOREWORD

BP believes in investment in quality. That is the philosophy which guides our arts sponsorship in the UK and internationally. We are delighted to have had the privilege of working with the National Portrait Gallery over the last decade. Through the BP Portrait Award I hope that we have helped not only to give portrait painting renewed momentum, but also to give an even wider audience an appreciation of the true value of a fascinating art form.

LORD BROWNE OF MADINGLEY
Group Chief Executive, BP

The Portrait Award, now in its twenty-second year at the National Portrait Gallery and twelfth year of sponsorship by BP, continues to be a highly successful annual event aimed at encouraging young artists to focus upon and develop the theme of portraiture within their work. Many artists who have had their work on show have gained commissions as a result of the considerable interest generated by the Award.

The entire competition is judged from original paintings and is followed by an exhibition of works selected from the entries. The competition receives over 600 entries annually, out of which an average of sixty paintings a year are exhibited and eight prize winners are selected.

The competition is open to artists aged between eighteen and forty inclusive on 1 January of the year of the Award. The entry must be in oil, tempera or acrylic, and should be painted from life with the human figure predominant. A full list of rules and an entry form can be obtained from: BP Portrait Award, National Portrait Gallery, St Martin's Place, London WC2H 0HE.

INTRODUCTION

The annual Portrait Award, now in its twelfth year of sponsorship by BP, has had a profound impact on British contemporary art. **William Packer**, artist, critic, and former Award judge, reflects on the practice of painted portraiture.

I remember very clearly the inception of the Portrait Award at the National Portrait Gallery in 1980. The competition was limited from the start to artists of forty-one years or under, which threshold, to my frustration and annoyance, I had crossed only that very summer. It was a competition in which I would certainly have tried my luck, for I am one of almost the last generation of art students in Britain that was brought up under the old dispensation, in which the life model was the central study. And from the nude to the clothed figure, from the full-length to the head, and from the head to the portrait, the progression was not merely natural but inevitable. The earliest painting of my own I have is a portrait of my younger sister, and though my subsequent practice has varied over the years, veering at certain periods into abstraction, the interest in the portrait has remained with me, and I have painted portraits at intervals ever since.

Back in the early 1980s, I felt that this new award was all the more to be welcomed for being specifically directed towards what had been one of the principal disciplines of Western painting since the Renaissance. For portraiture embraces some of the greatest achievements of that tradition, from Holbein (1497/8–1543) and Bellini (1801–35), by way of Velázquez (1599–1660) and Rembrandt (1606–69), to Degas (1834–1917), Cézanne (1839–1906) and Sargent (1856–1925). Yet by the late twentieth century, portraiture was clearly at a discount in terms both of critical acceptance and practical engagement. While it remained true that from the 1950s to the 1980s painters of real distinction had continued to work directly from the figure, and indeed to paint the portrait head, they did so increasingly against the grain of critical and curatorial fashion. To be a painter of the figure at all, let alone of the portrait as such, was as much as to declare oneself old-fashioned, irrelevant and out-of-touch. It may seem hard to believe it now, but when the Arts Council gave Lucian Freud (b.1922) a retrospective at the Hayward Gallery in London in 1974, the decision to do so was widely considered to be wilfully regressive, if not an active provocation to the seriously *engagé* and avant-garde. And how long it took for

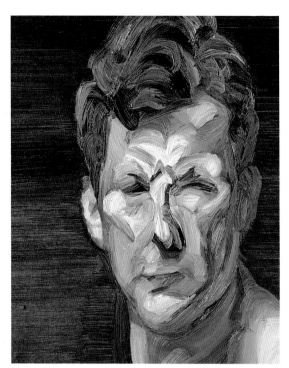

LUCIAN FREUD,
b.1922
Self-portrait, 1963
Oil on canvas,
305 x 251mm
(12 x 9⅞")
National Portrait
Gallery (NPG 5205)

Euan Uglow (1932–2000), no less distinguished and remarkable an artist of the figure, to be recognised at the highest level. For Norman Blamey (1914–2000), even into his eighties, there was to be scarcely any recognition at all, let alone anything near his due. There were also always a number of good and distinctive painters of the figure and the portrait showing regularly at the Royal Academy, such as Robert Buhler (1916–89), Ruskin Spear (1911–90), John Ward (b.1917) and Carel Weight (1908–97) – but the Academy in those days was still, well, *the* Academy.

How then, in so cold a critical climate, were aspiring painters to nerve themselves to declare even a passing interest in the portrait and yet hope still to be taken seriously as artists fully up-to-date and of the moment? It is a measure of the immediate and continuing success of the Portrait Award that it was a question that soon no

longer needed to be asked. Certainly the prize money helped, for nothing concentrates the ambitious mind like the prospect of a hefty sack of gold. And if the art schools themselves did not necessarily encourage their charges to enter, students would still feel nothing ventured, nothing gained. More to the point, the Award suggested a venture that might not have otherwise occurred to younger artists, whose interest hitherto lay elsewhere, as worthwhile. It has always been fundamental to the Award's success that the portrait should again be seen as perfectly normal an engagement for the self-respecting and ambitious artist. To be a portrait painter, that is to say, is not necessarily thereby to hide oneself behind a brass plate on the door and an exclusive commitment to the genre, never to escape.

A NEW GENERATION

Looking back, even I, my own self-centred reservations apart, can see that the age limit served an immediate and justifiable purpose. For, at a stroke, a whole generation of younger artists found the portrait to be suddenly a respectable and worthy consideration. The reinvigoration of the old-established Royal Society of Portrait Painters over the past twenty years by a steady access of younger members is hardly a coincidence, while the National Portrait Gallery itself has similarly broadened the scope of its commissioning. At a stroke, the portrait commissioned for the collection from every winner of the Award has regularly and incrementally added to the pool of artists now thought suitable for such a job. And where the winners have led, many of the mere exhibitors have followed, even to the Gallery's surprise. And where these institutions have led, the public has followed, and the painted portrait is once again a broadly accepted social attribute.

But quite where these younger artists under forty came, and indeed still come, from is something of a puzzle. British art schools have for the most part never actively helped the cause. There is much lip-service paid to the importance of the figurative disciplines in art education, and in certain art schools departments of

drawing have been re-established, life-rooms reinstated and fellowships for drawing variously set up. But there is as yet no evidence of actual instruction taking place in the old rigours of objective observation and analysis and technical command, even in drawing, let alone in painting from the figure. Instead there is only spurious theory and self-indulgent self-expression. Indeed the question asks itself of who now could teach at such a level in the old way, when by now the art school masters themselves were never thus instructed. That old, long-accrued, practical and philosophical inheritance of visual enquiry and technical command is no longer being passed from artist to artist down the generations with any regularity, as once it was, if at all, and soon will disappear altogether, having been squandered in less than forty years. The wheel will need to be reinvented, ever a long and tedious process.

THE WHOLE PICTURE

The quality of the entries for the Portrait Award, year on year, is therefore something of a mystery, and a miracle besides. And if recent years have seen the criticism levelled that the Award exhibition, if not the winning entry, has become generally less exciting and more predictable, we should only remember that the point of art is not novelty and excitement, but rather the quality of what is actually achieved. Any remark upon such levelling-off and consistency of quality should be taken as simply a compliment and encouragement, in recognition of a position now well established and accepted.

The evident and increasing reliance by many artists upon the photographic reference, rather than upon observation and experience direct, has been noted. It was of course evident from the earliest days of the Award, and indeed artists of all kinds have been using the camera as they would any other useful tool since the invention of photography. There is no difficulty with the educated and particular use of the photograph as reference and reminder, indeed as direct stimulus and aid. But a painting of a photograph remains a painting of a photograph and not, in this connection, of a person. The

photograph must be interpreted, and what it distorts, obscures, or leaves out altogether, is as much to be understood as what information it actually affords. This understanding is only to be achieved by long study and comparative experience of whatever it is that is drawn, painted and photographed.

The painting has still to be resolved in the painting, in the doing, whatever the nature of its source or reference – which is David Hockney's point, much misunderstood by those who should know better, in his recent researches into the history and manner of the use by artists of optical instruments, aids, mirrors and lenses, long before the invention of the fixed photograph[1]. Such devices were never the determining masters of the work, but useful only in the laying-out of image or composition, and in the subsequent incidental making of checks and registrations, for no painting could be done upside-down in a darkened room, or under a blanket to keep out the light. And so it is, or should be with the photograph, the danger in its use lying only in a literal and unthinking acceptance of the image it offers as a truth. The early practice of the Portrait Award, now discontinued, was to set a photograph of the subject alongside the painting in the exhibition, which as a documentary confirmation was naturally popular with the public as a comfort and reassurance. What else it did was to remind us that the photographic portrait as such, wonderful though it can be at its most accomplished, is an altogether different thing.

THE ARTIST AND THE MODEL

But that is rather by the way. What is reassuring about the Award itself is that throughout its short history the winning artists have for the most part worked directly from the model. In short, it shows. There has never been a policy in this direction, nor should there be. Indeed, in the early years of the Award, the initial selection for submission of the work from which the final exhibition was to be chosen was always made on the basis of transparencies sent in. The judges were thus looking at photographs that by their very nature tend to favour

work that is stronger in the image than perhaps in the painting, along with that which is more photographically based and thus photographically effective. It was always a considerable relief, therefore, to see that despite the odd misjudgement, the paintings called in were for the most part sufficiently painterly in themselves, though their actual size, whether large or tiny, was often a surprise. The case is simply that quality declares itself, and paintings worked directly from the model are inevitably richer on the surface, more subtle, various and intuitive in the mark, and closer in their particular detail and response. Most important of all, they tell us so much more, and quite as much about the artist as about the subject. The eventual commitment in 1990 to a selection only from works actually submitted, with all the logistical complications and expense this entailed, was a brave but necessary step to take.

A true portrait is much more than a painting of a simple image, flat upon the surface of the canvas, a graphic exercise. At whatever level it is conducted, and flawed, inept or masterly as the result may be, it is inevitably a painting about a situation and a relationship, sustained over time. And that relationship between the artist and the model is as particular as it is strange. It is, at its deepest level, one of unique and long-sustained intimacy born of immediate, close and intensive scrutiny in a shared place, breathing the same air. It is a kind of conspiracy, a personal and shared endeavour, to which both artist and sitter are active parties, albeit on one side a suspended kind of animation. And each exercise in portraiture is unique, so too the relationship between the individual parties that is given an extra spice by a certain mutual tension and anxiety. The sitter is perhaps self-conscious and uncertain of the outcome, unused to being the motionless subject of such scrutiny. The artist's studio is an unfamiliar place, with its smell and paraphernalia, and even to sit at home can be disconcerting in the temporary invasion and disruption. The painter, on the other hand, has a professional duty to perform, a character and presence to capture, and a reputation to protect and, if possible, enhance. Artist

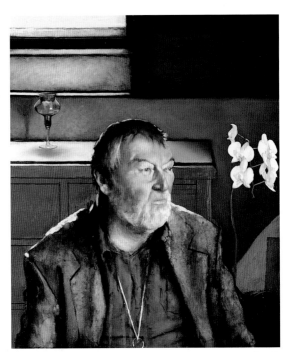

WINNER'S COMMISSION, 1998
JOHN FOWLES, b.1926
Tomas Watson, 2001
Oil on linen,
712 x 614mm
(28 x 24⅛")
National Portrait
Gallery (NPG 6584)

and model come thus close together in a contrived, unusual and heightened situation. It is no wonder, in such circumstances, that the one thing has led so often to another.

As for the self-portrait, here the relationship, the essential confrontation, is at its most intensive and revealing, whether the apparent intention is mere self-flattery and promotion, unremitting self-analysis, or mere objective, disinterested curiosity as to why that once eternally familiar face within the mirror grows ever more odd and foreign and unlike. As with a mantra, meaning seems inexorably to drain away, no matter how we dress ourselves up, put on hats and cloaks, peer meaningfully out of the shadows or, with a moral masochism, look for every blemish, warts and all. It is for others to read the truth of it.

Artists have each their methods, their habits of procedure. They play music, perhaps, to amuse their victim (I mean subject), turn on the wireless, talk inconsequentially

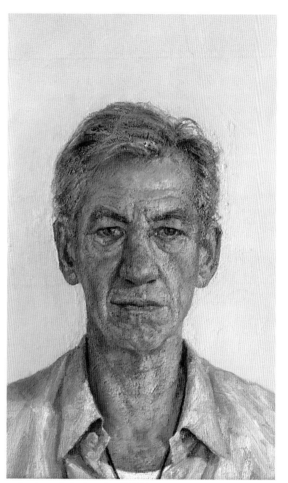

WINNER'S COMMISSION, 1999

SIR IAN MCKELLEN, b.1939
Clive Smith, 2002
Oil on canvas,
336 x 206mm
(13¼ x 8⅛")
National Portrait
Gallery (NPG 6610)

only abruptly to break off. Millais, it seems, covered several miles walking back and forth a session. The model perhaps sits still, but rarely so very still, which is always a problem and vexation of spirit to the artist, in whom a certain peremptoriness is all too understandable. The model, on the other hand, may chat away, which may help a bit and if not can always be stopped by the artist turning his attention to the mouth. Then again, there are sitters, especially of a grander sort, who

would rather endure in silence while the artist gets on with the job in hand, the sooner to bring the session to an end. A certain frustration and unease is inevitable on either part. And, as in all relationships, there is to this something of a struggle, how ever so small, between the two, as to who should be the master, who call the tune – the painter or the client, the active or the acquiescent, the payer or the payee. The question is always: 'whose idea was it in the first place?'

PAINTING THE FUTURE

But whatever the nature of the relationship and the struggle, it remains a profound and seriously metaphysical business. For the portrait, and the great portrait with a peculiar force, brings us as third party into the equation, as we sit at the artist's shoulder, looking together at the sitter, and sharing vicariously in the peculiar, intimate scrutiny and confrontation. Time passes as we follow the progress of the painting. Imaginatively we share the space, and enter the experience. There is, to the true portrait, always something more than the mere business of a likeness, and indeed true portraiture is never about likenesses, but about an essence and a spirit and a deeper truth. Such at least is the aspiration. And it is this something more, this essential sense and quality of an actual personal presence, and of an artist's particular response and relation to it, that gives to the portrait always its peculiar charge. The greatest virtue of the BP Portrait Award at the National Portrait Gallery is that it serves to remind us, year by year, of the great historical tradition and its discipline. There is clearly to be life to the painted portrait for a good time yet.

1. *Secret Knowledge – Rediscovering the lost techniques of the Old Masters*, David Hockney (Thames & Hudson, 2001), p.35.

The 2002 Award received 661 entries. Out of the fifty-five selected by the judges for display at the National Portrait Gallery, eight prize winners were chosen.

The first prize was awarded to Catherine Goodman, who received £25,000 plus, at the judges' discretion, a commission for £3,000 to paint a well-known person.

Žygimantas Augustinas was placed second, winning £5,000, and in third place Mark Shields was awarded £3,000. Special commendations, to the value of £1,000 each, were given to Mark Entwisle, Massimo Franco, Vasiliki Gkotsi, Dean Marsh and Kristina O'Donnell. Most of the prize winners have exhibited widely and have their work in public and private collections.

The judges for the 2002 Award were Charles Saumarez Smith, Director of the National Portrait Gallery, Des Violaris, Director UK Arts and Culture, BP, Andrew Graham Dixon, critic, Nicola Hicks, artist, Jock McFadyen, artist, Fiona Shaw, actress, and Stuart Pearson Wright, artist and winner of the BP Portrait Award 2001.

FIRST PRIZE
ANTONY
Catherine Goodman
Oil on canvas, 1265 x 1265mm (49³/₄ x 49³/₄")

23

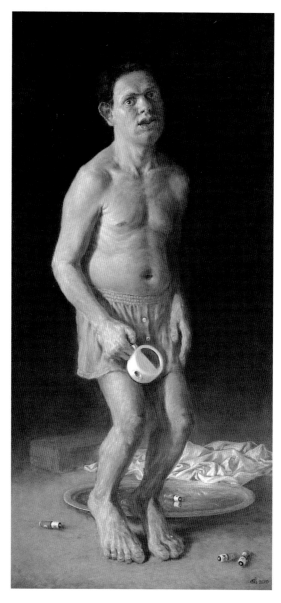

SECOND PRIZE
MAN WITH UTENSIL (OSCAR)
Žygimantas Augustinas
Oil on canvas, 1175 x 590mm (46¼ x 23¼")

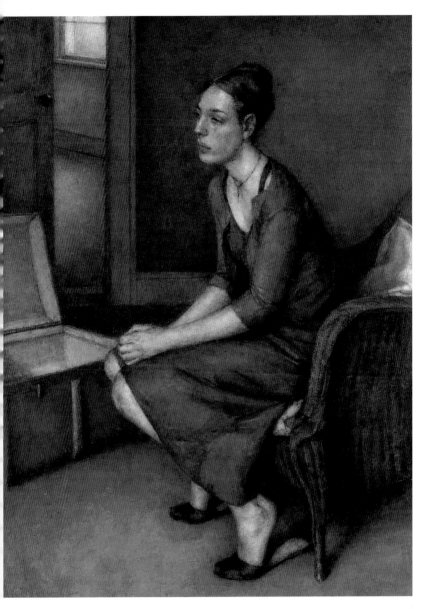

THIRD PRIZE
SEATED WOMAN
Mark Shields
Acrylic on board, 1200 x 880mm (47¼ x 34⅝")

COMMENDED
MÁRIA
Mark Entwisle
Oil on canvas, 660 x 610mm (26 x 24")

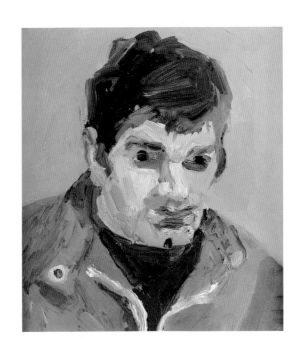

COMMENDED
SELF-PORTRAIT
Massimo Franco
Oil on board, 330 x 310mm (13 x 12¼")

27

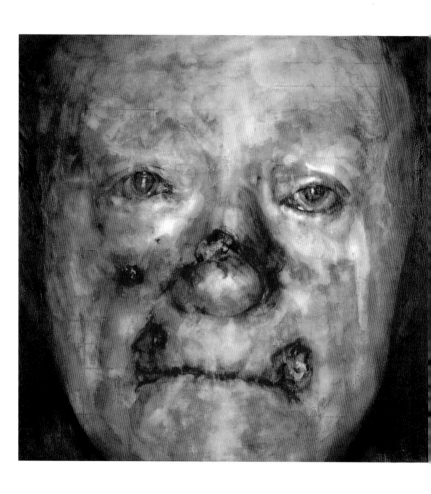

COMMENDED
PROJECT 2001: LIFE IS A BITCH NO. 1
Vasiliki Gkotsi
Oil on canvas, 1630 x 1630mm (64$\frac{1}{8}$ x 64$\frac{1}{8}$")

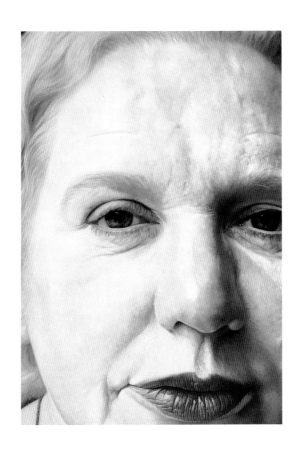

COMMENDED
ROSALIND SAVILL CBE
Dean Marsh
Oil on panel, 365 x 255mm (14³/₈ x 10")

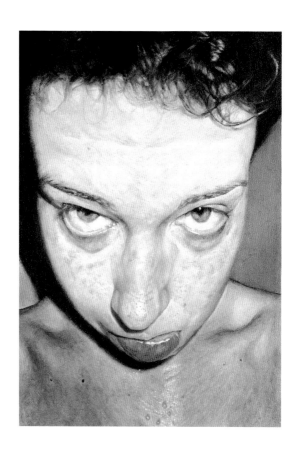

COMMENDED
SELF-PORTRAIT
Kristina O'Donnell
Oil on canvas, 380 x 250mm (15 x 9⅞")

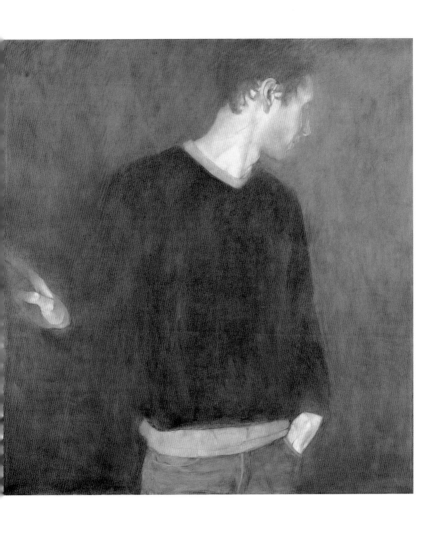

ANDY
Jackie Anderson
Oil on canvas, 1140 x 830mm (44$^{7}/_{8}$ x 32$^{5}/_{8}$")

31

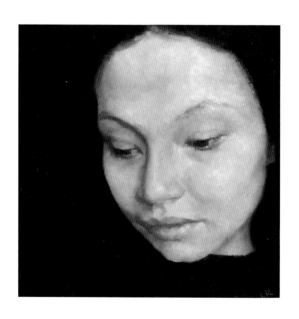

REFLECTION
Jennifer Anderson
Oil on canvas, 430 x 430mm (16⁷/₈ x 16⁷/₈")

FAYETTE MIDDLE SCHOOL
Esao Andrews
Oil on board, 770 x 920mm (30³/₈ x 36¹/₄")

33

BIRTHDAY GIRL
Nicholas Archer
Oil on linen, 1680 x 1320mm (66$^1/_8$ x 52")

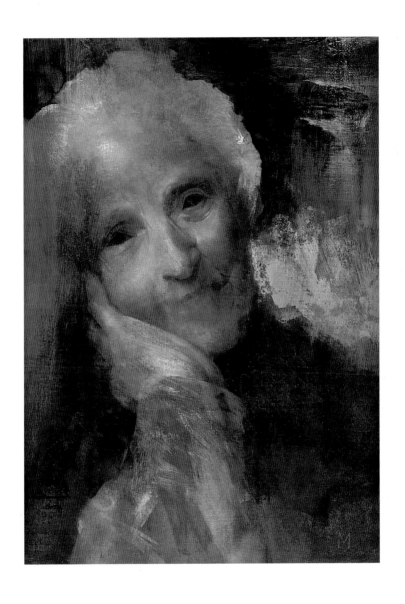

MOTHER
Maryanne Aytoun-Ellis
Tempera on linen, 760 x 540mm (29⁷⁄₈ x 21¹⁄₄")

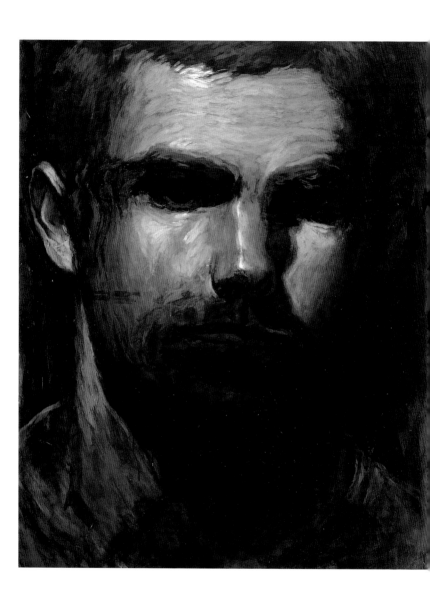

SELF-PORTRAIT
Tomás Baleztena
Oil on canvas, 1040 x 850mm (41 x 33½")

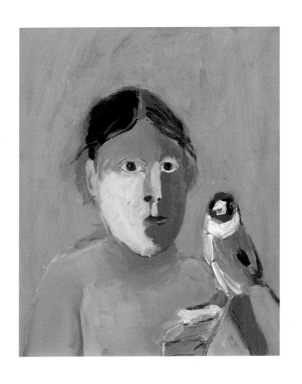

THE BIRD KEEPER'S DAUGHTER
Matthew Batt
Acrylic on canvas, 300 x 250mm (11¾ x 9⅞")

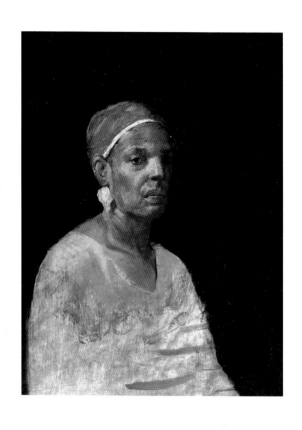

WOMAN WITH HEADWRAP
Noah Buchanan
Oil on panel, 406 x 305mm (16 x 12")

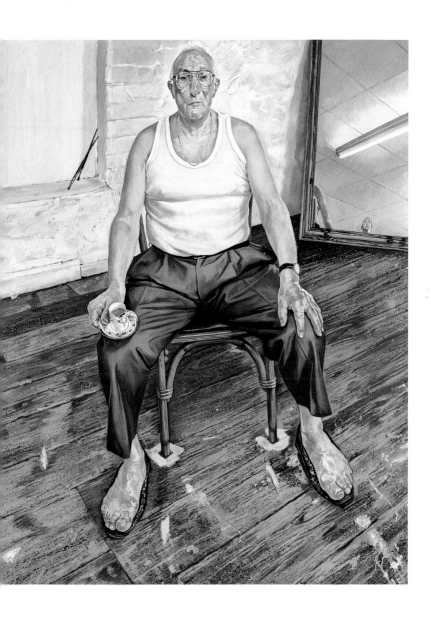

EDDIE
Jason Butler
Oil on canvas, 1560 x 1260mm (61$^{3}/_{8}$ x 49$^{5}/_{8}$")

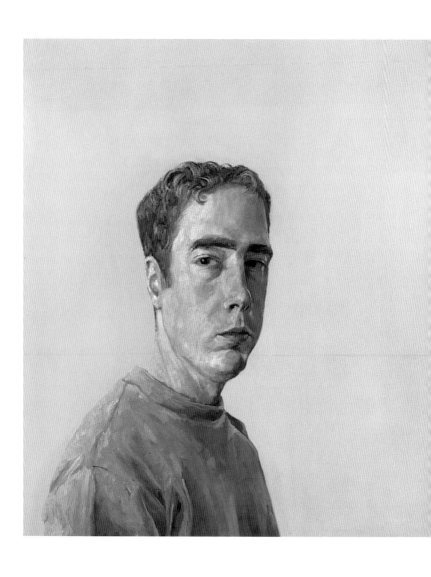

SELF-PORTRAIT IN BLUE JUMPER
Comhghall Casey
Oil on linen, 840 x 740mm (33⅛ x 29⅛")

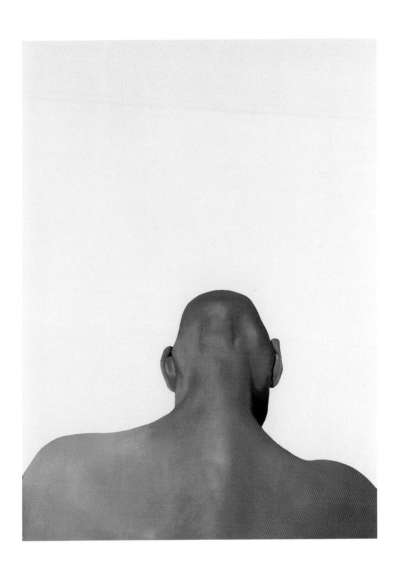

PETE SEATED
Anton Cataldo
Oil on board, 610 x 460mm (24 x 18⅛")

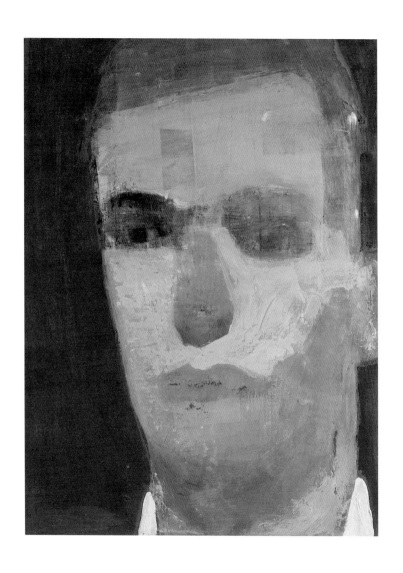

PARANOID ANDROID
Daniel Cimmermann
Oil and encaustic on canvas, 610 x 460mm (24 x 18⅛")

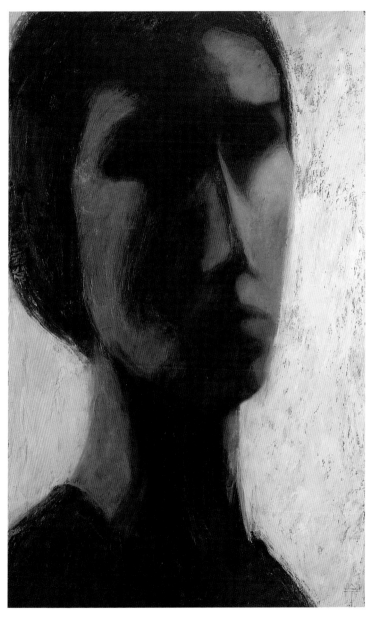

SVETA
Timur D'Vatz
Oil on canvas, 1780 x 1070mm (70$\frac{1}{8}$ x 42$\frac{1}{8}$")

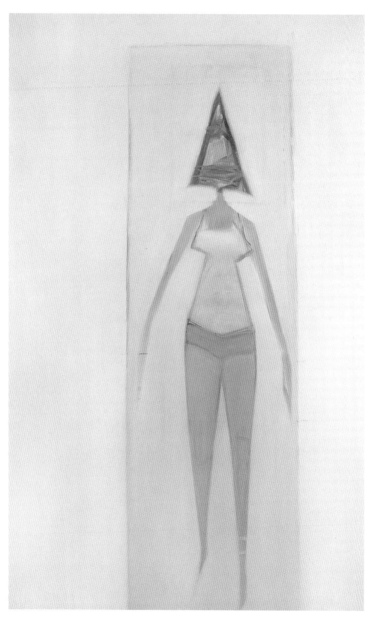

PORTRAIT OF A. D.
David Dipré
Oil on canvas, 1780 x 1095mm (70⅛ x 43⅛")

44

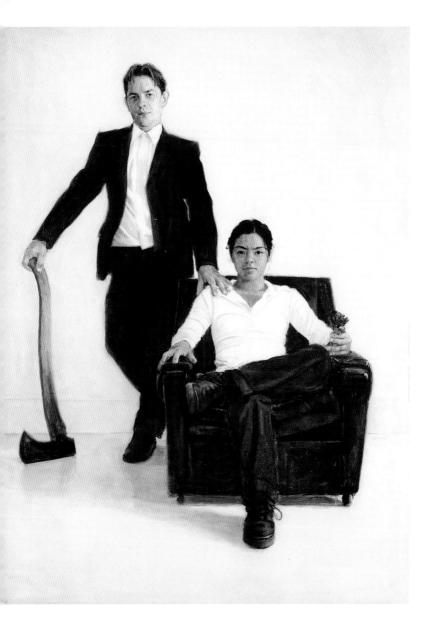

MR DAVID FRANKEL AND MISS GRACE AYSON
Gavin Edmonds
Oil on canvas, 1575 x 1168mm (62 x 46")

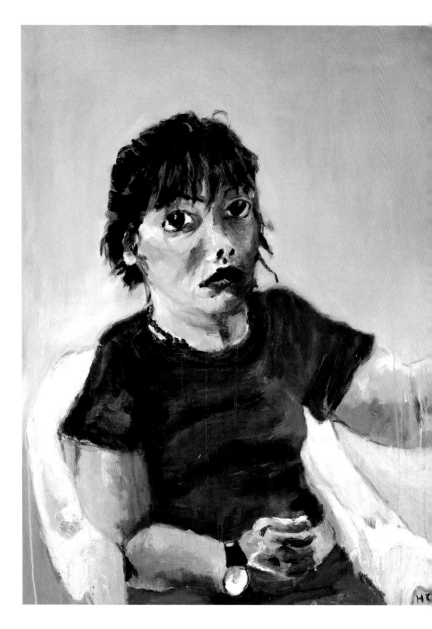

ME
Hannah Glickstein
Acrylic on canvas, 1020 x 670mm (40^{1}/$_{8}$ x 26^{3}/$_{8}$")

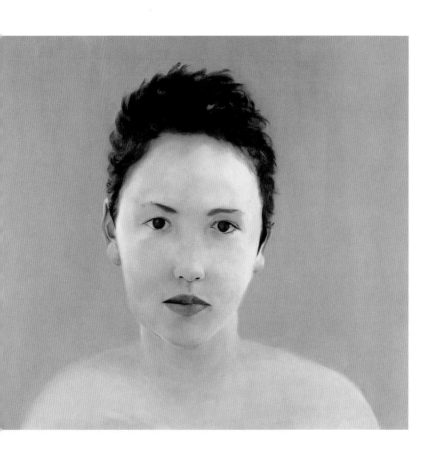

RUTH
Adam Hahn
Oil on canvas, 1210 x 1300mm (47⅝ x 51⅛")

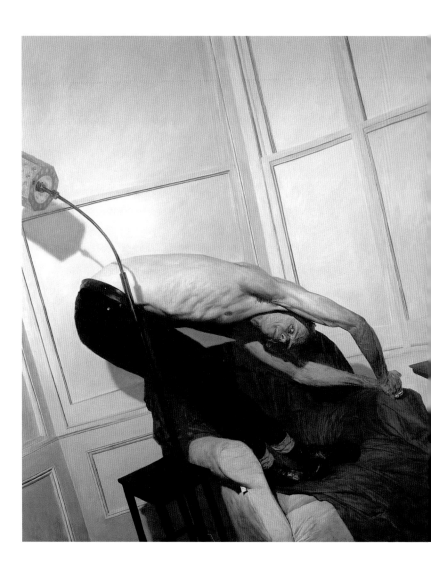

THE MALE IMPERATIVE TO ASSERT
WHILE THE FEMALE IS CONTENT TO REMAIN SUBMISSIVE
Philip Hale
Oil on linen, 2000 x 1700mm (78$^{3}/_{4}$ x 66$^{7}/_{8}$")

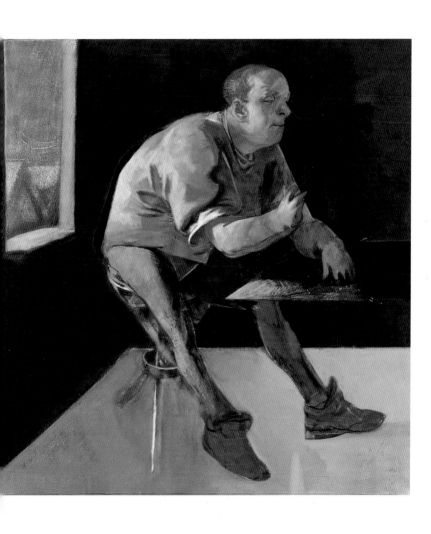

REACHING FOR BOTTLES
Toby Hunt
Oil on canvas, 950 x 900mm (37³/₈ x 35³/₈")

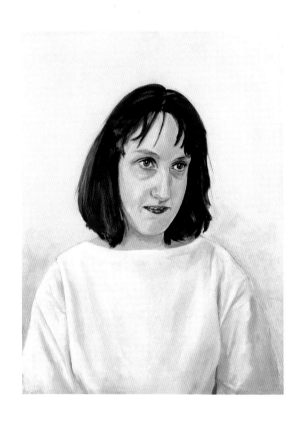

MOLLY
Josie Jammet
Acrylic on board, 350 x 250mm (13³/₄ x 9⁷/₈")

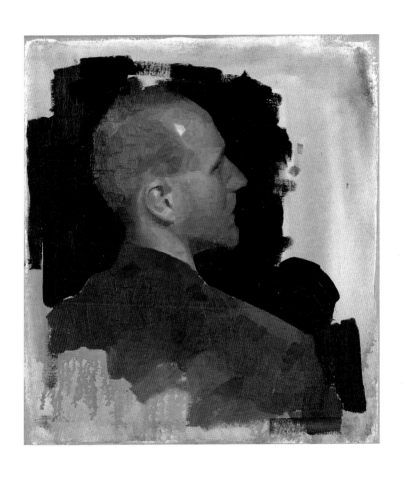

MILLIONS LIKE US
Diarmuid Kelley
Oil on linen, 508 x 406mm (20 x 16")

51

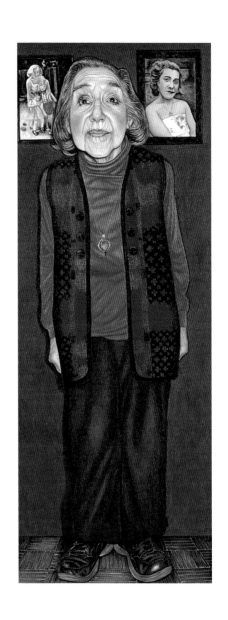

PICTURES OF LILY
Sadie Lee
Oil on canvas, 1010 x 455mm (39³/₄ x 17⁷/₈")

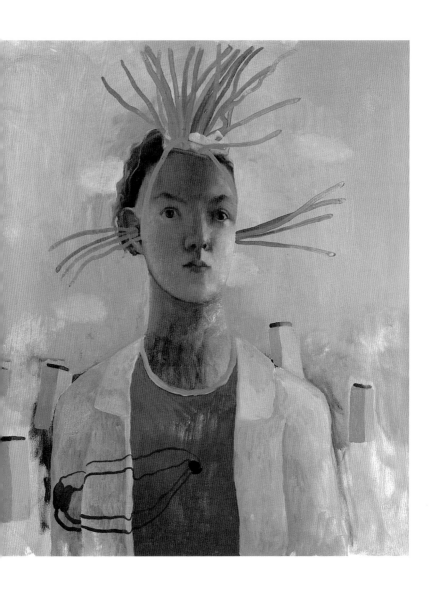

MARCO POLO'S RESPONSIBILITY
Diana Leslie
Oil on canvas, 980 x 850mm (38⅝ x 33½")

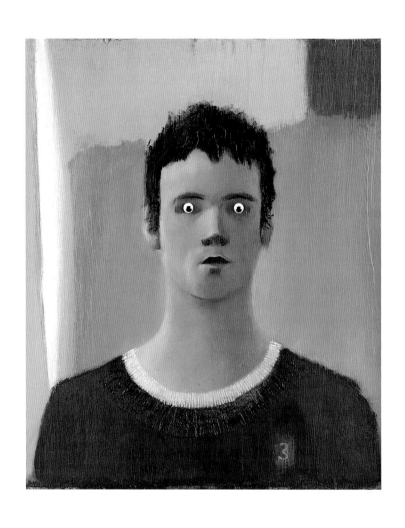

WINDOWS TO THE SOUL
Brian Love
Oil on linen, 590 x 510mm (23¼ x 20⅛")

54

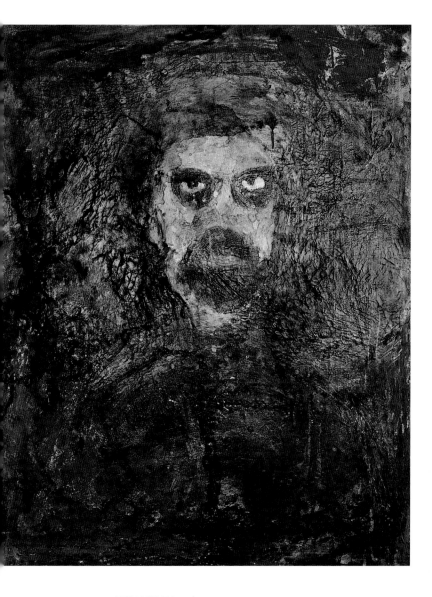

MICK LOVLEY
Oliver Lovley
Acrylic on canvas, 1016 x 813mm (40 x 32")

55

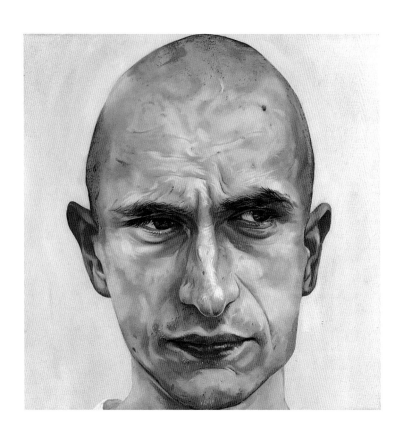

MUG SHOT
Catherine MacDiarmid
Oil on canvas, 560 x 560mm (22 x 22")

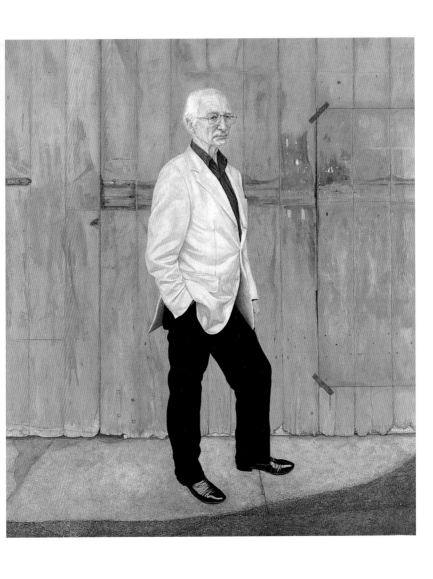

THIS STRANGE NEW FELLOW
Fergus Mayhew
Oil on board, 950 x 840mm (37³/₈ x 33¹/₈")

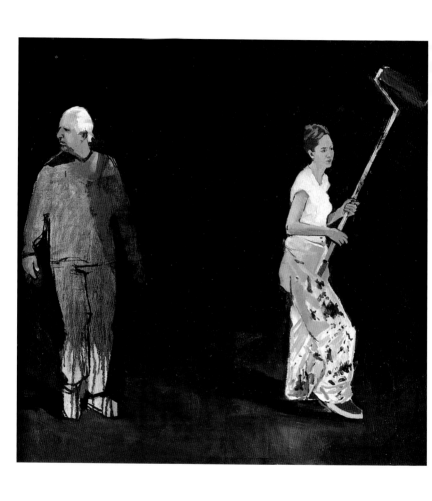

PAINT IT BLACK
Sarah McConkey
Oil on canvas, 715 x 715mm (28⅛ x 28⅛")

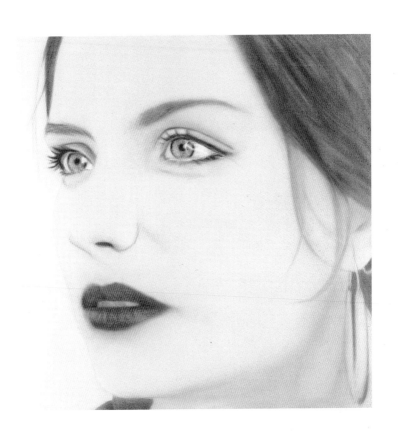

JANE PANNELL
Josie McCoy
Oil on canvas, 600 x 600mm (23⅝ x 23⅝")

SELF-PORTRAIT
Susan McFarlane
Oil on canvas, 280 x 280mm (11 x 11")

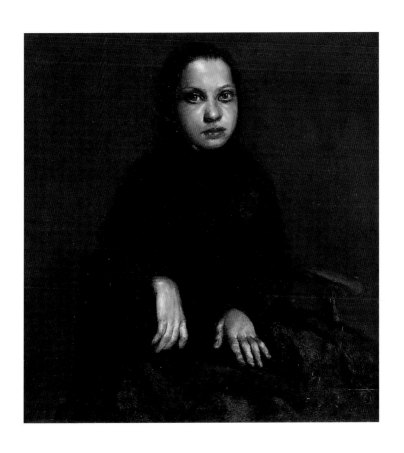

ELEONORA M
Anastassios Missouras
Oil on board, 691 x 673mm (27$\frac{1}{4}$ x 26$\frac{1}{2}$")

61

ILONATIC
Ilona Niemi
Oil and mixed media on board, 600 x 400mm (23^5/$_8$ x 15^3/$_4$")

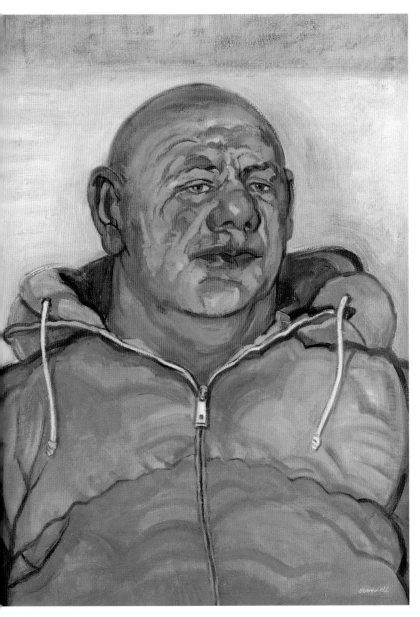

JEGGS
Adrian O'Donnell
Oil on canvas, 855 x 700mm (33⅝ x 27½")

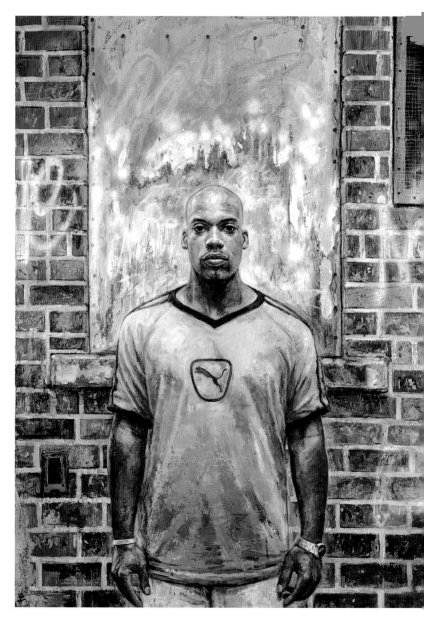

PORTRAIT OF JEROME
Tim Okamura
Oil on canvas, 1730 x 1220mm (68 1/8 x 48")

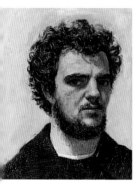

TRIPTYCH
Carl Randall
Oil on canvas, 250 x 457mm (9⁷/₈ x 18")

DOUBLE PORTRAIT WITH SMALL BONES
Daisy Richardson
Oil on canvas, 612 x 612mm (24⅛ x 24⅛")

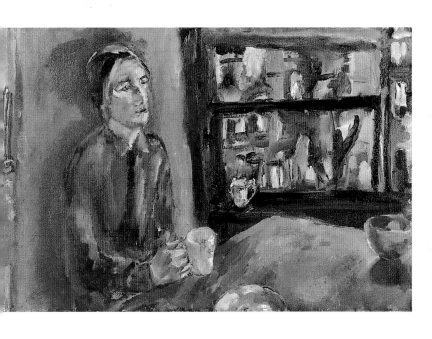

ANDY CRANSTON
Lorna Robertson
Oil on canvas, 780 x 1160mm (30$\frac{3}{4}$ x 45$\frac{5}{8}$")

67

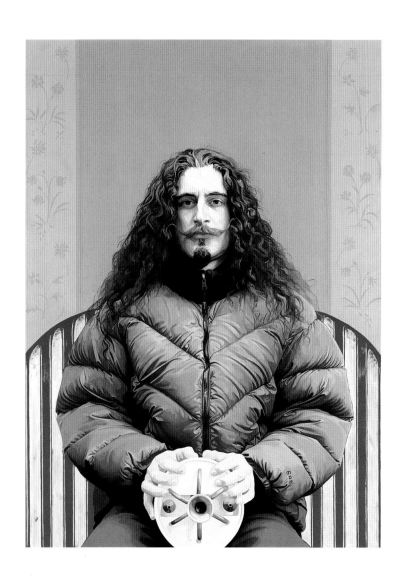

MAHARAJA OF SKUP
Stephen Rogers
Oil on board, 710 x 580mm (28 x 22⅞")

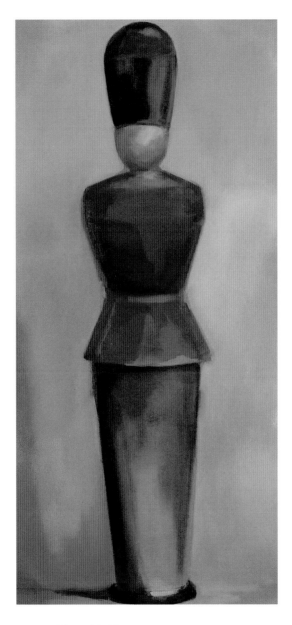

ROYAL GUARD
Gideon Rubin
Oil on canvas, 1930 x 915mm (76 x 36")

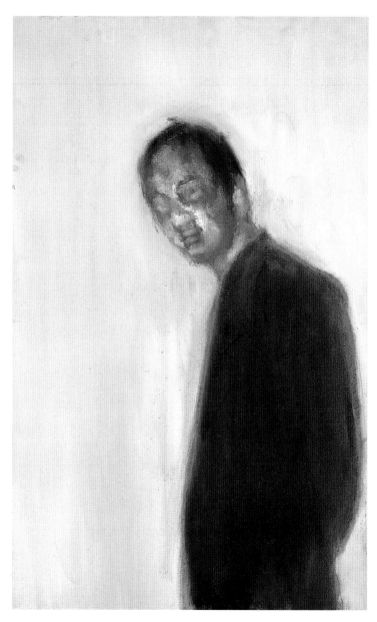

ALEC LEAVING
Daniel Shadbolt
Oil on linen, 950 x 600mm (37³/₈ x 23⁵/₈")

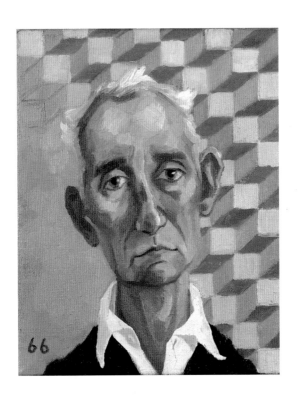

PATRICK PROCKTOR
Rupert Shrive
Oil on linen, 250 x 200mm (9⅞ x 7⅞")

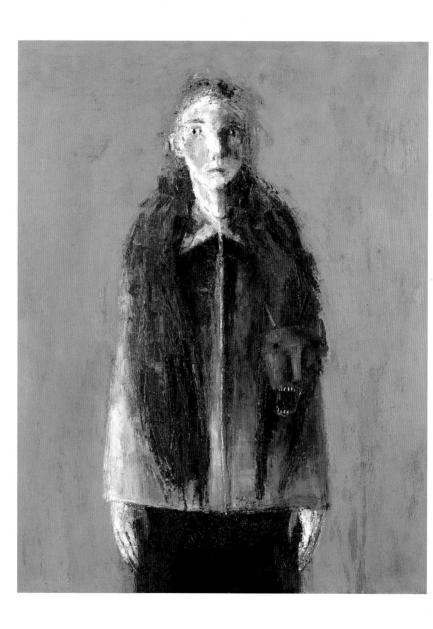

MEMENTO
Lisa Stokes
Oil on canvas, 1050 x 940mm (41³/₈ x 37")

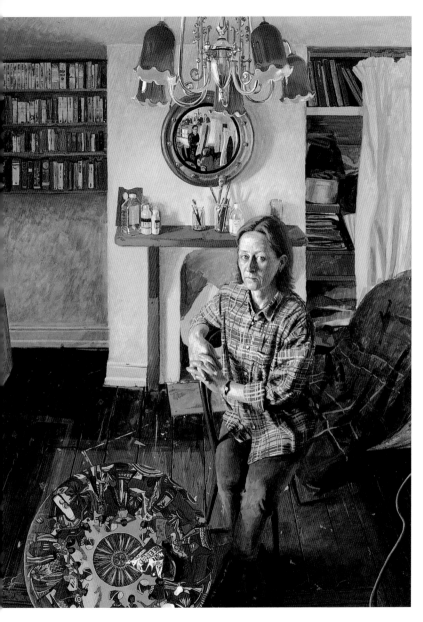

MUM
Benjamin Sullivan
Oil on canvas, 1180 x 880mm (46½ x 34⅝")

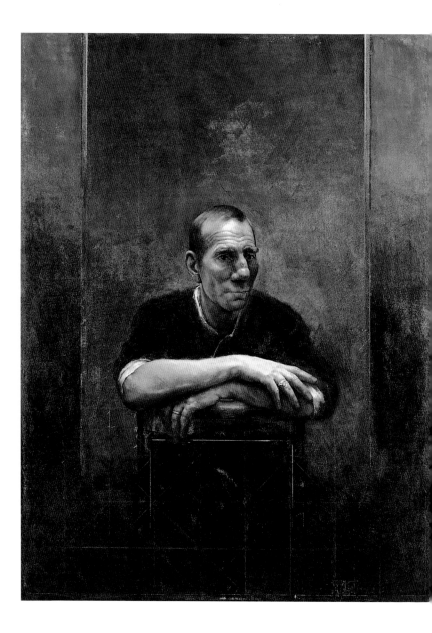

PETE POSTLETHWAITE
Christopher Thompson
Oil on canvas, 1380 x 1080mm (54³/₈ x 42¹/₂")

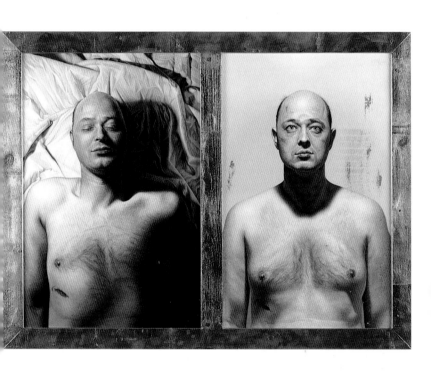

PRETENDING TO BE JESUS (33)
Andrew Tift
Acrylic on canvas, 600 x 800mm (23⅝ x 31½")

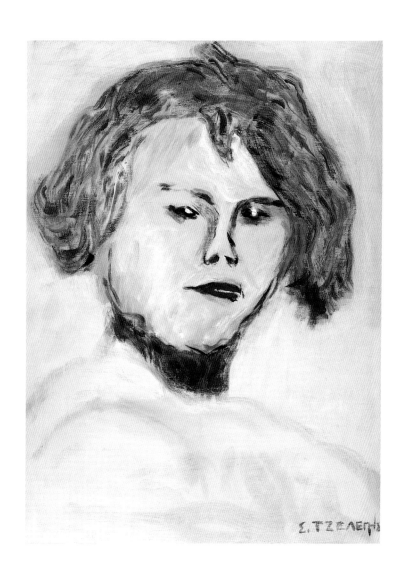

LILITH
Stergios Tzelepis
Acrylic on canvas, 665 x 570mm (26⅛ x 22½")

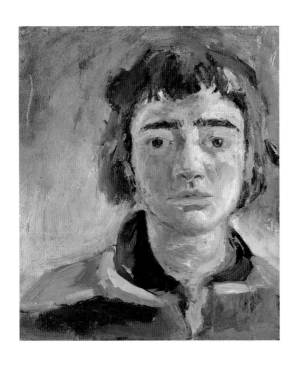

SELF-PORTRAIT
Jessica Wolfson
Oil on canvas, 450 x 400mm (17³/₄ x 15³/₄")

Many young artists entering the BP Portrait Award choose subjects close to home: for practical and economic reasons, sitters are usually family, friends and the artists themselves. However, since 1991, the creation of the BP Travel Award has provided a winning artist with the opportunity to broaden their horizons through painting in a different environment, either in Britain or further afield.

To enter the Travel Award artists are invited to submit a proposal outlining their idea, itinerary and budget. The shortlisted artists are interviewed by a panel of judges and the following year the winner exhibits their resulting work at the Gallery during the BP Portrait Award exhibition.

Past projects have been diverse: Si Sapsford, who won in 2000, visited Salcombe, Devon, and Reykjavik, Iceland, to depict the rigorous lives of two lifeboat crews. The previous year, Jennifer McRae spent a month studying the staff and students of a Brussels art school, where the emphasis was on working from the life model. Last year's winner, Alan Parker, hung up his policeman's hat for a month but continued to go to work, making a series of paintings of the officers and public on his Leicestershire beat. Sarah Howgate, Contemporary Curator at the National Portrait Gallery, asked Alan Parker about the experience:

Having been – to my great surprise – awarded the BP Travel Award, it hasn't been hard to 'stick to the script'. My plan, not to travel per se but to paint the people that travel to Leicester, has been a pleasure to fulfil.

Eighty per cent of a good portrait is to do with having a great subject. By 'putting yourself in the way' of a good sitter you have won half the battle and I can say from experience that being a police officer is a surefire way of finding interesting sitters. After I had arrested the men who became the subjects for my painting Bootboys*, on a bitter night last winter, they were cold and distraught, sat in the 'Chute' (a steel holding-cage where prisoners wait prior to being presented at the custody desk). They seemed too good an opportunity to*

**BP TRAVEL
AWARD 2001**
BOOTBOYS
Alan Parker
Oil on panel,
610 x 610mm
(24 x 24")

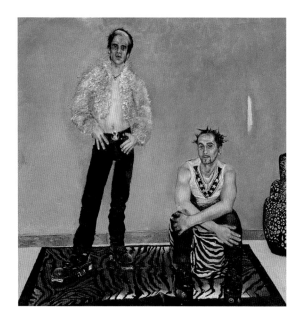

miss for this project, so I asked if they would sit for a portrait and, to my amazement, they agreed. With characters like these on every street corner, the paintings have virtually painted themselves and I have been inspired to put in plenty of time in the studio. And, most pleasingly, this time last year none of these people would have dreamed that they would ever have had their portrait painted, let alone have it hanging in the National Portrait Gallery.

This small collection of pictures, however, only scratches the surface of the city. When Joe Orton said that Leicester was '... the most boring city in England' he could never have anticipated that within a generation it would have become one of the most colourful places in the country. The huge influx of immigrants, along with a sea change in our views on so-called 'outsiders', mean that this relatively small Midlands' city has become so varied, so vibrant, that I am sure if Hogarth were around today he would have been up here with his easel double-quick.

Alan Parker, spring 2002

INDEX